In photography, the smallest thing
can be a great subject.

—Henri Cartier-Bresson

P
is for peanut

a photographic a•b•c

LISA GELBER • JODY ROBERTS

THE J. PAUL GETTY MUSEUM, LOS ANGELES

A is for

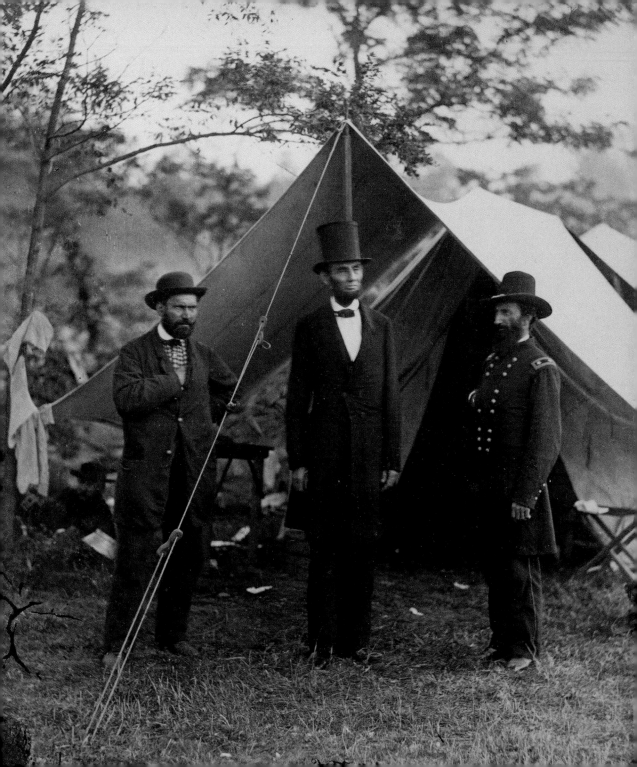

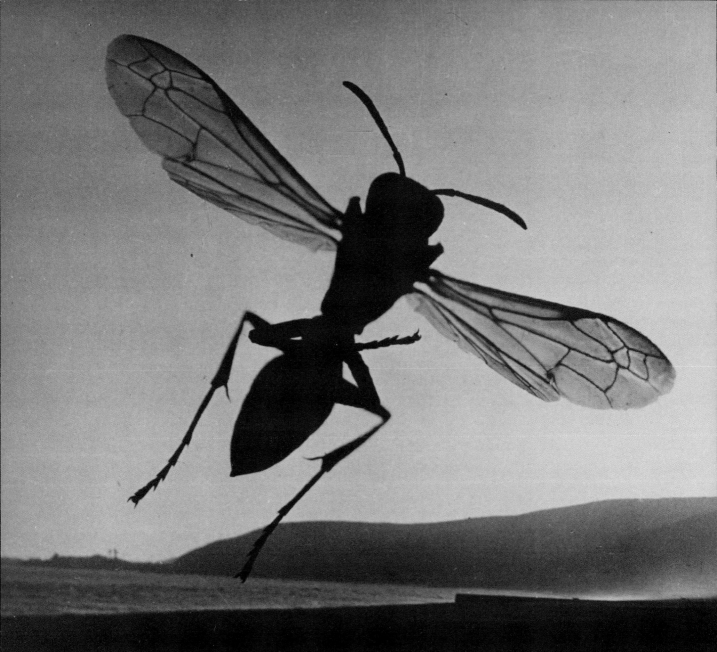

is for B
uzz

C

is for

chee

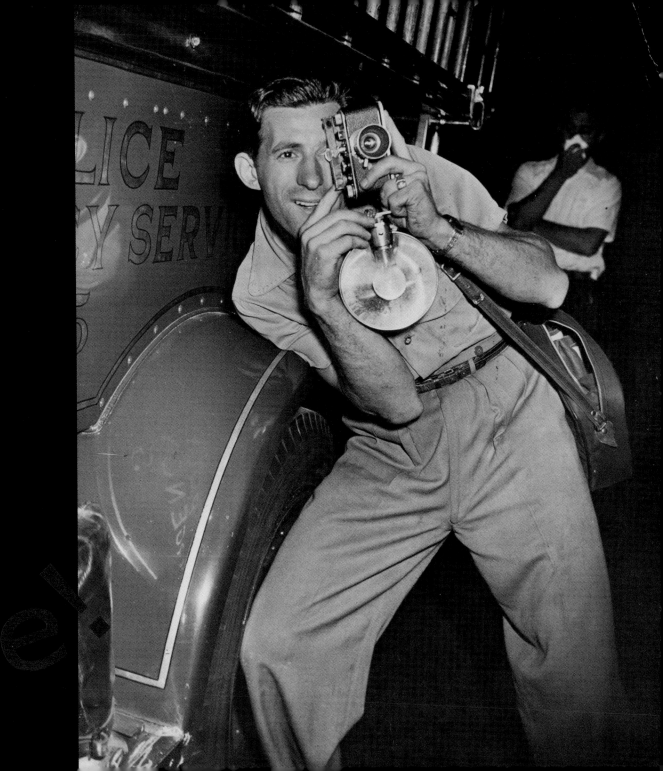

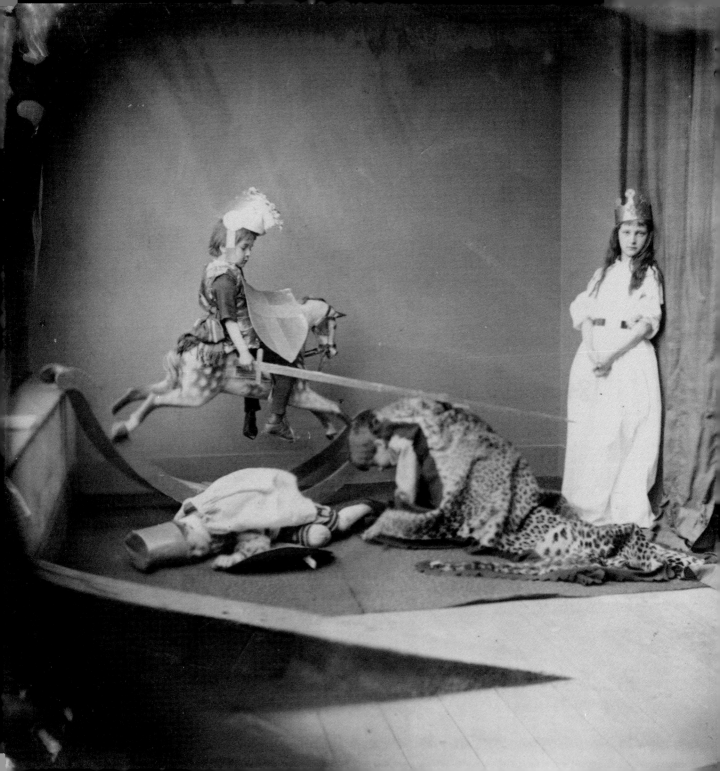

D

is for

dress-up

E is for

explore

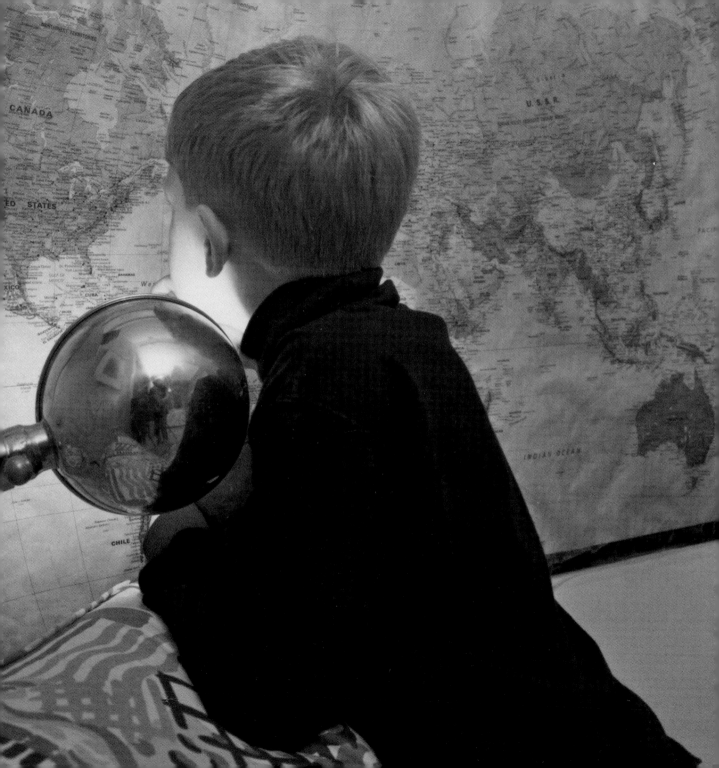

F

is for

follow-
the-
le

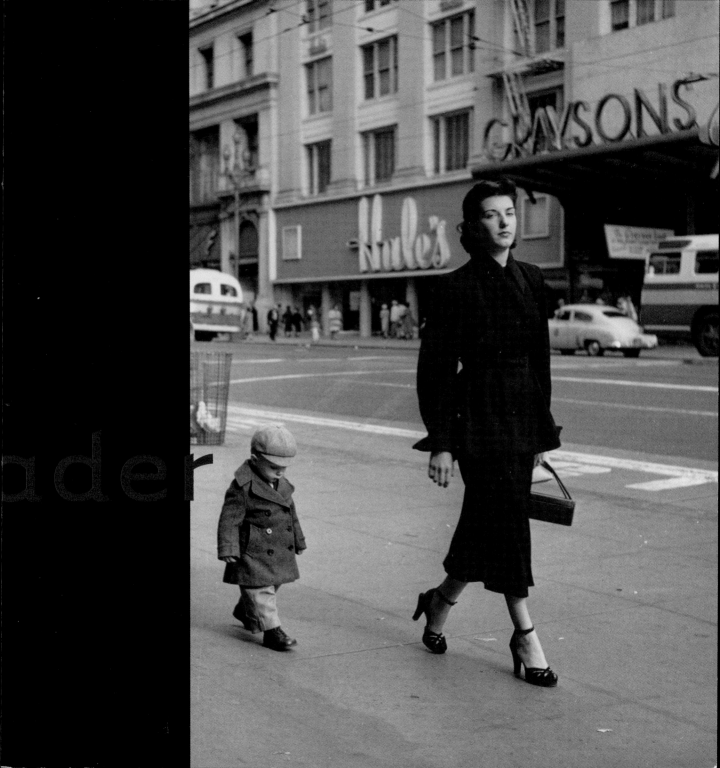

G

is for

guess w

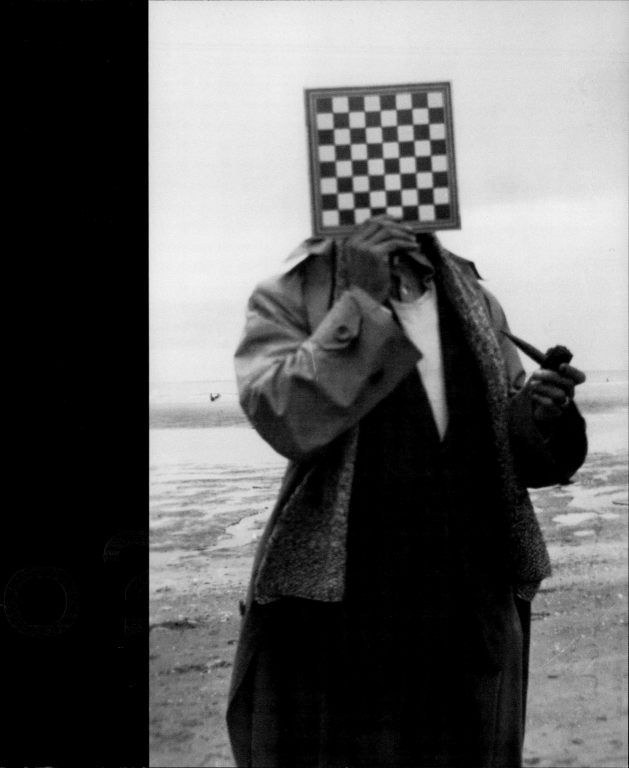

H

is for

heads

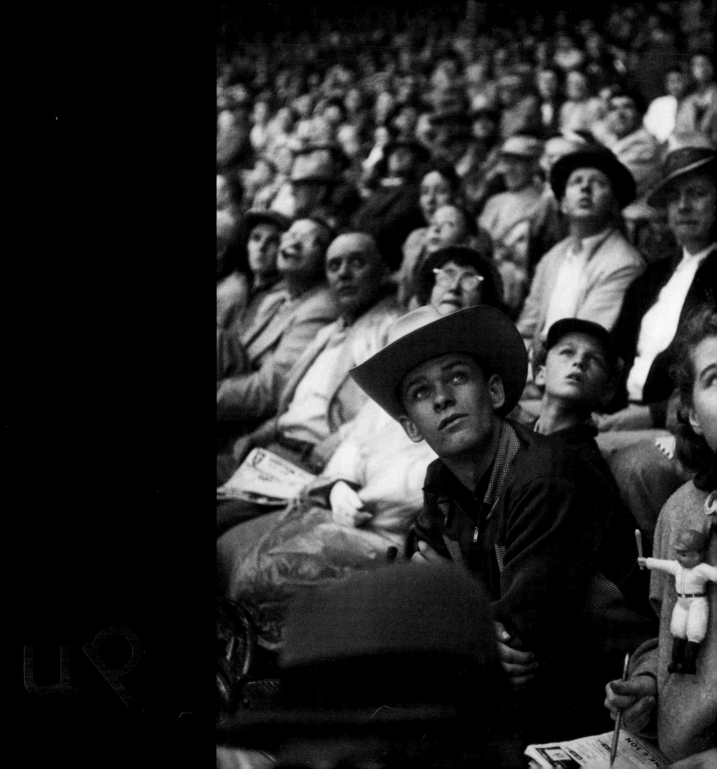

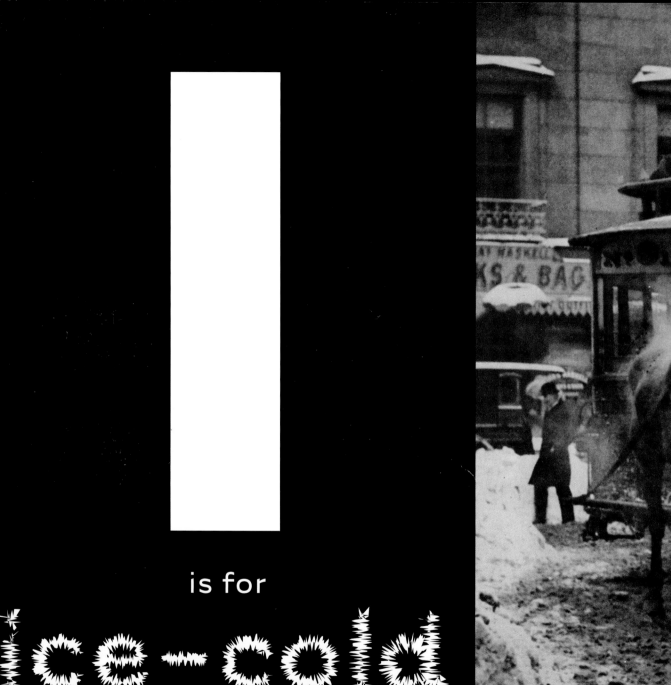

I

is for

ice-cold

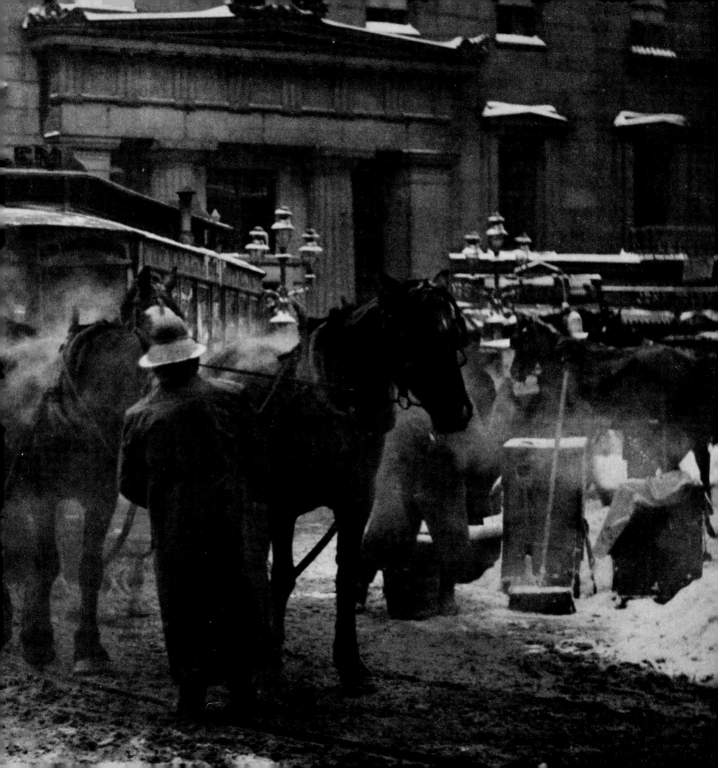

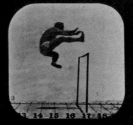
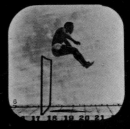
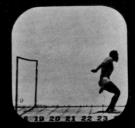

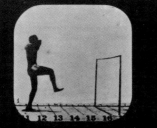
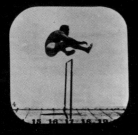
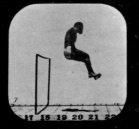

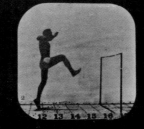
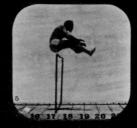
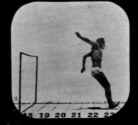

K

is for

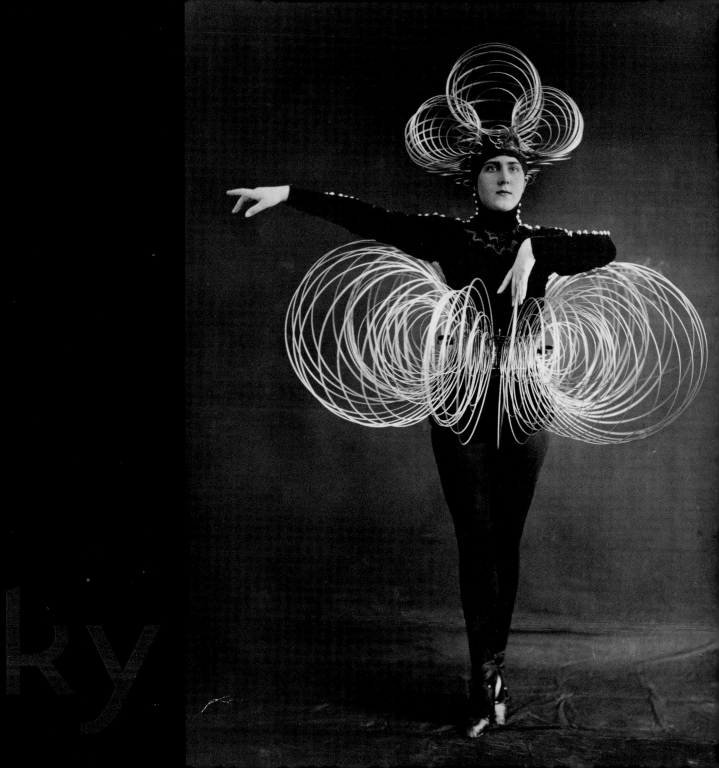

is fo

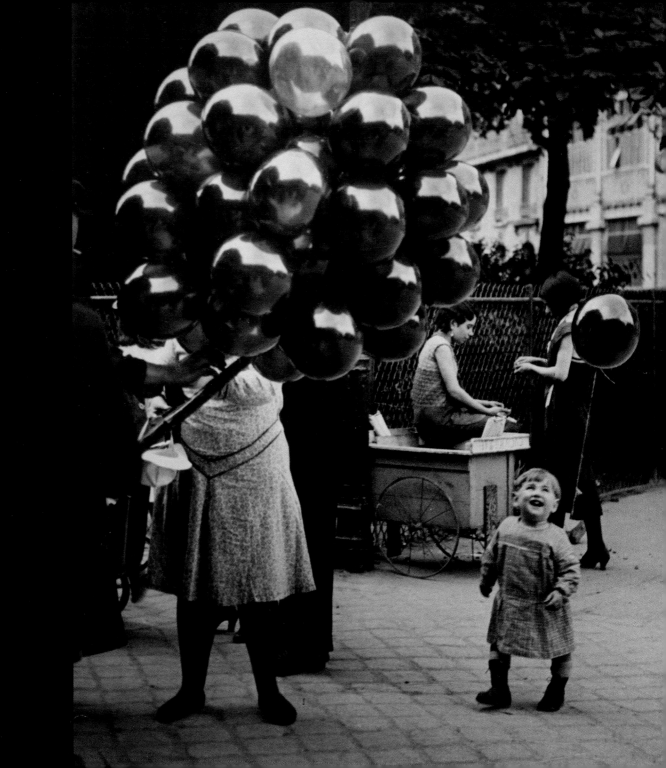

M

is for

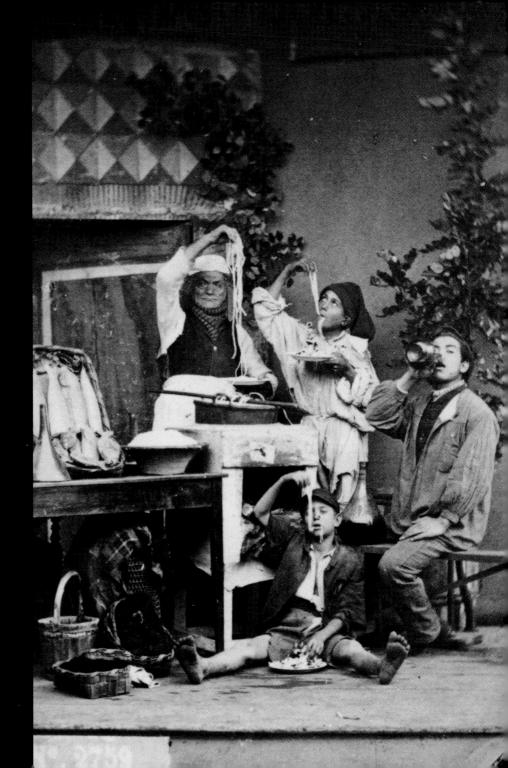

N

is for

neighborhood

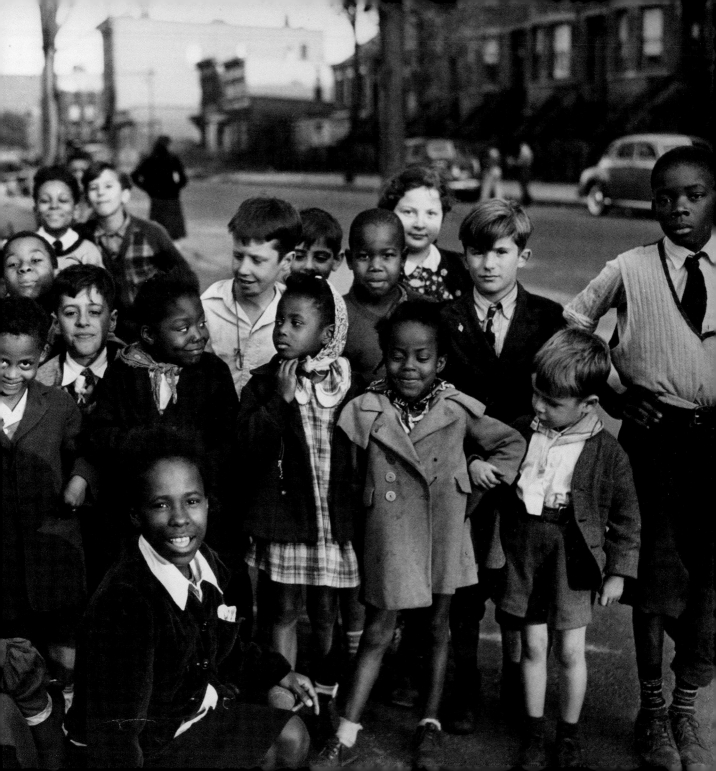

is for

obedient

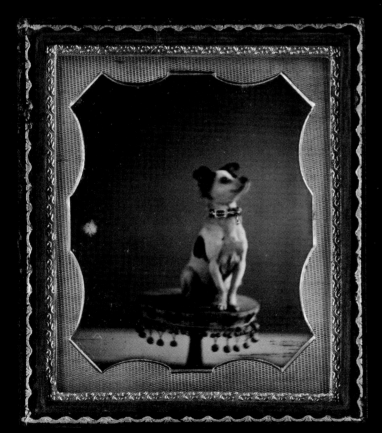

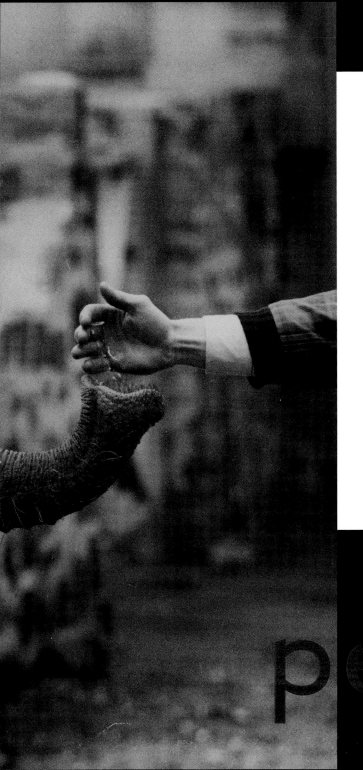

P

is for

peanut

is for

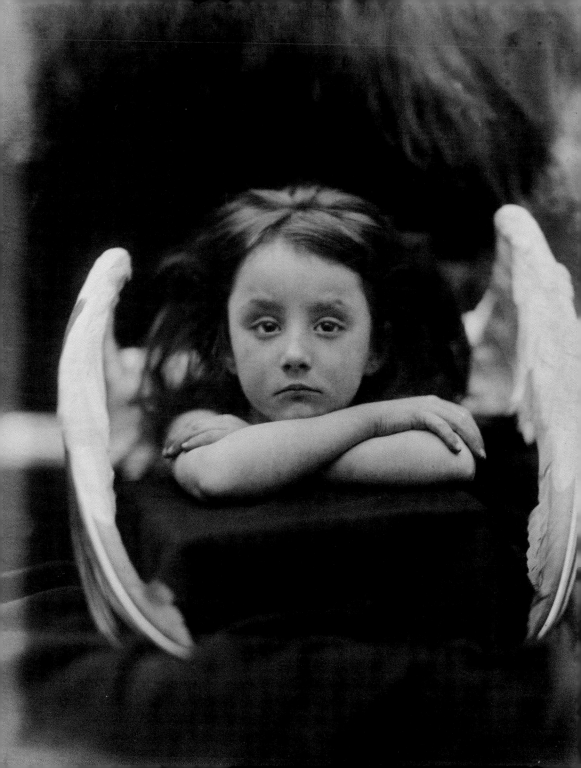

R is for

repe
repe

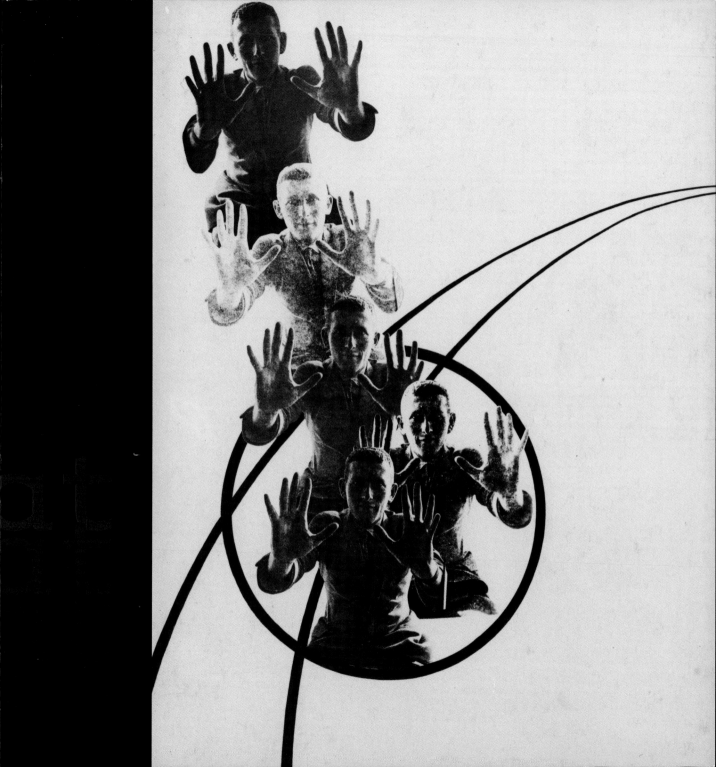

S is for

skinny

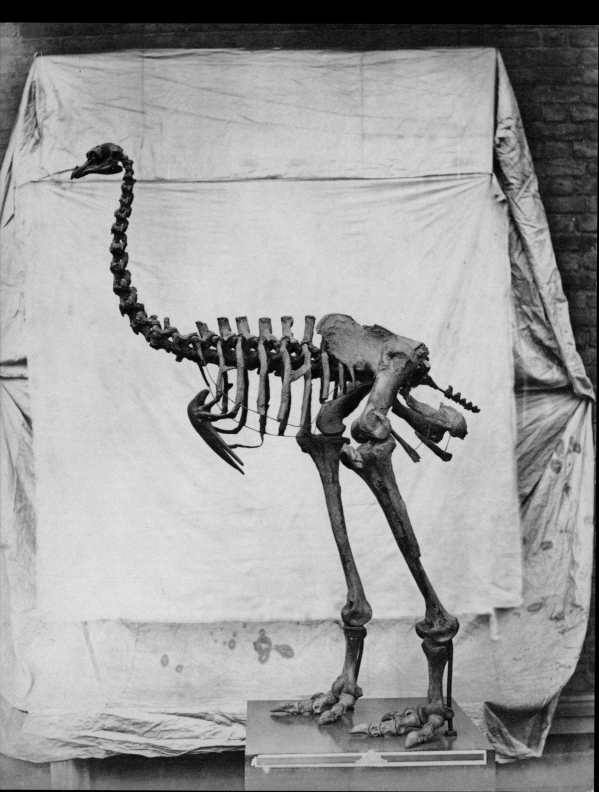

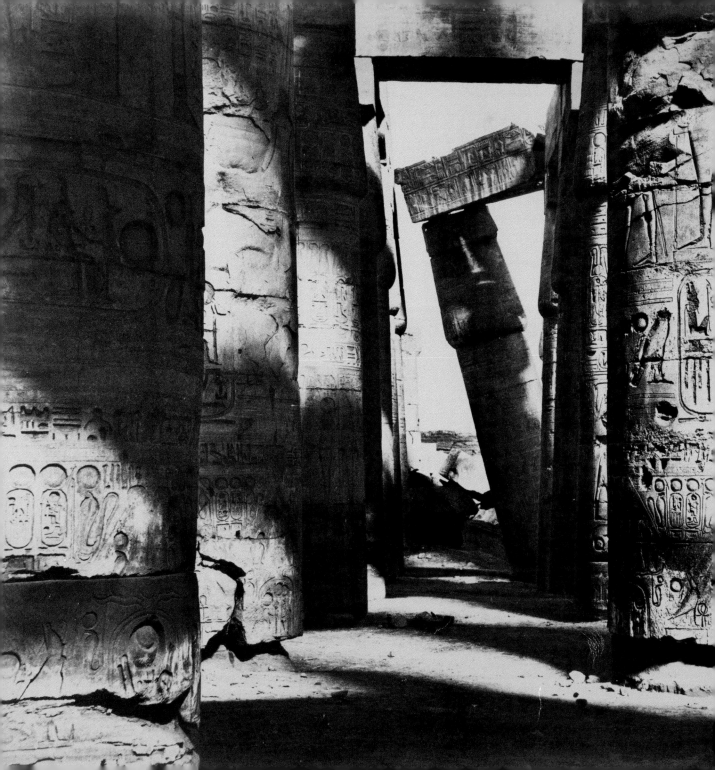

T is for

tilt

U is for upside

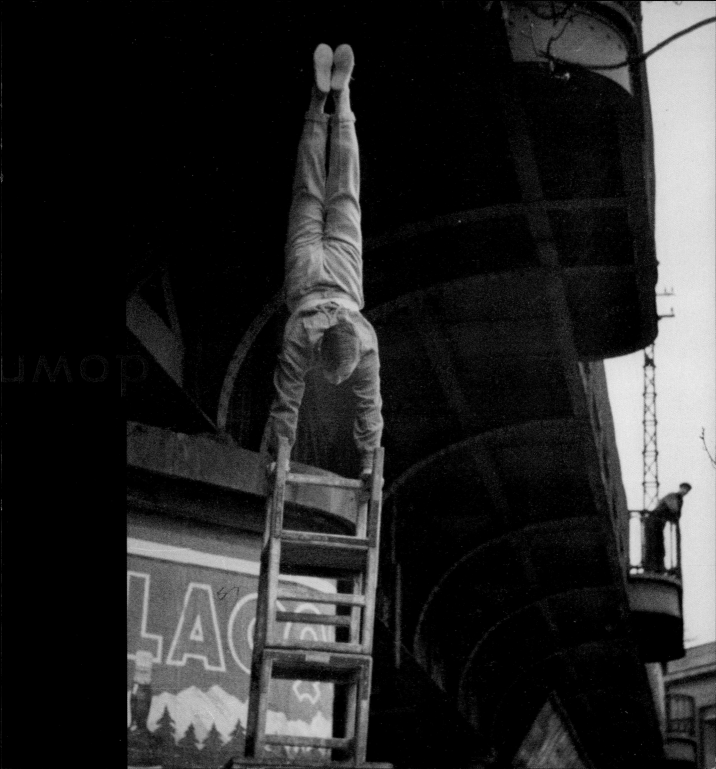

V is for

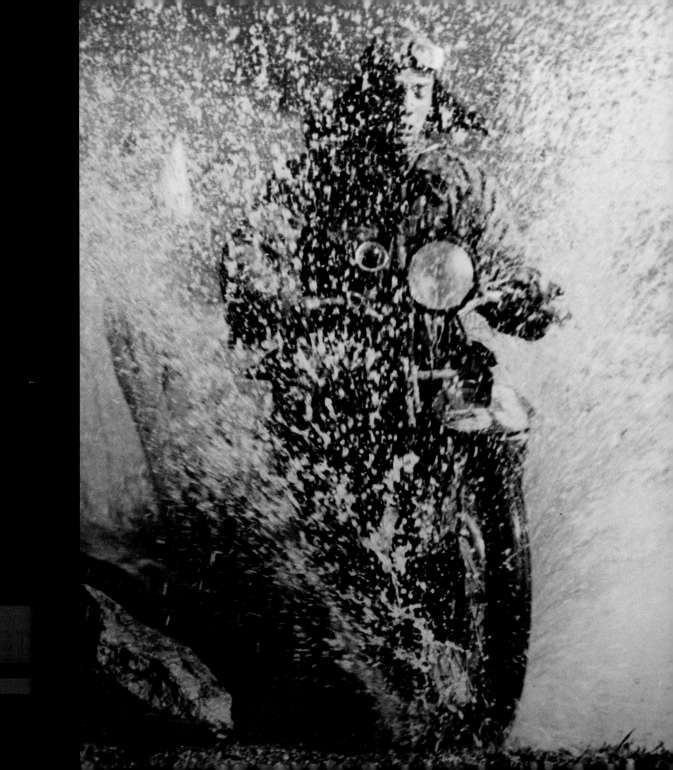

W

is for

whiske

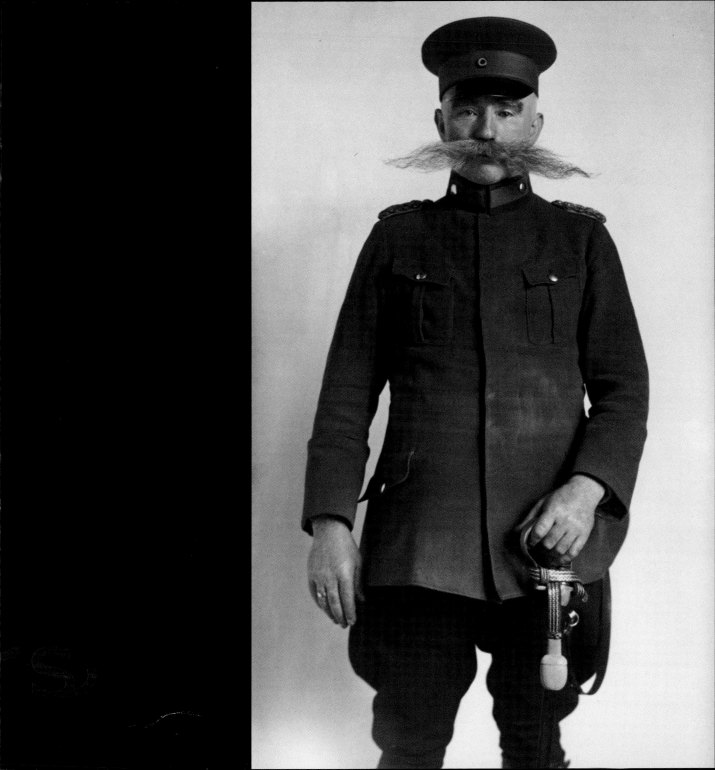

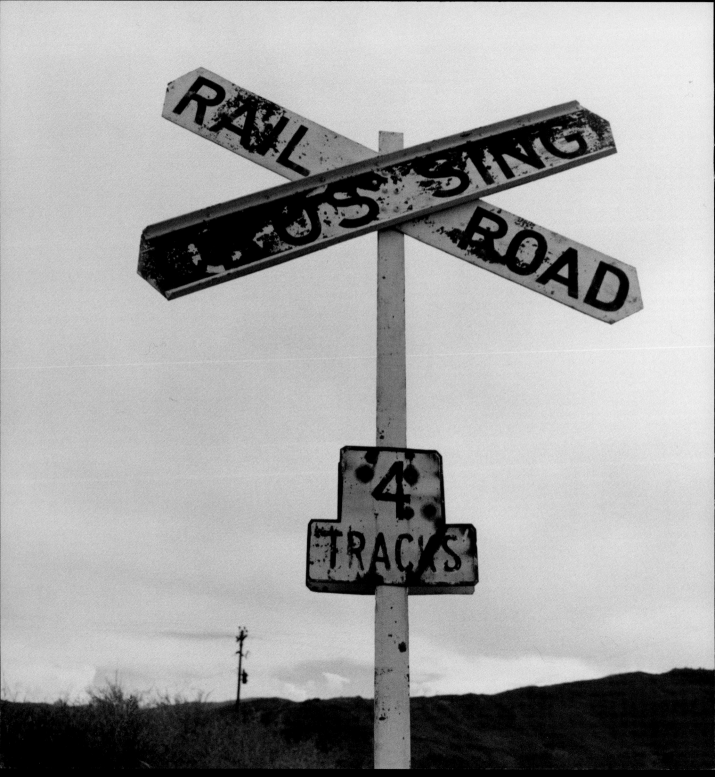

marks the spot

Y
is for
yikes

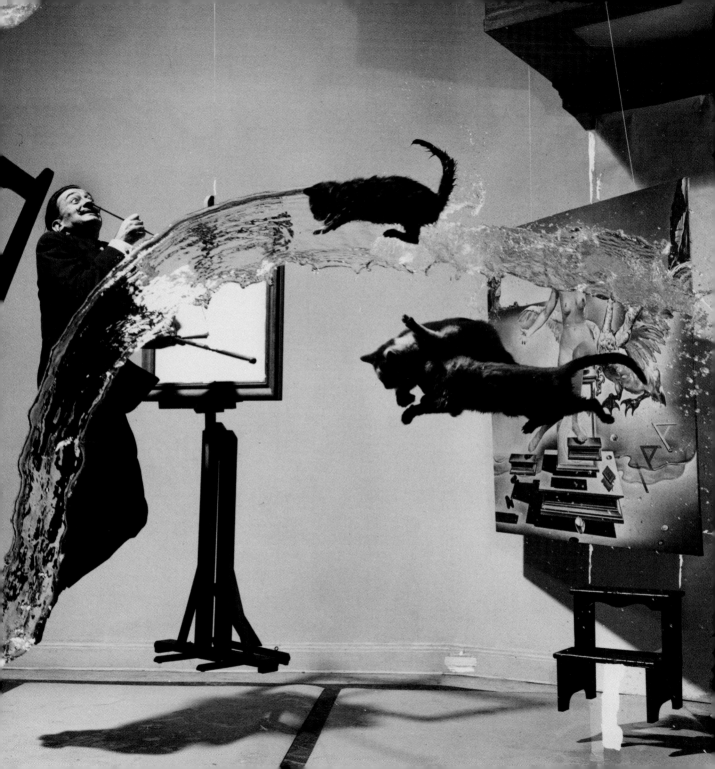

is for

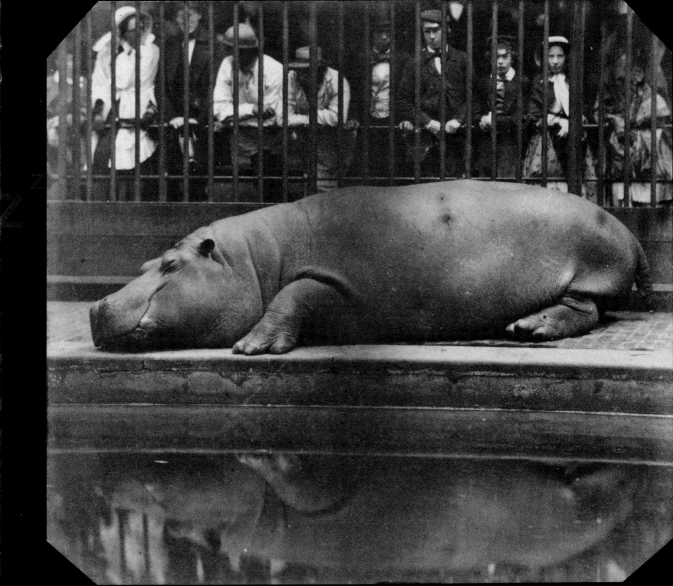

Did You Know?

Abe

On this Civil War battlefield, President Abraham Lincoln made time in his busy schedule to pose for his favorite photographer. Not the safest place to have your picture taken!

Buzz

By enlarging this fly so dramatically, Man Ray shows us what one insect must look like to another: huge!

All photographs are in the collection of the J. Paul Getty Museum.

Lincoln on the Battlefield of Antietam, Maryland
1862
ALEXANDER GARDNER
(American, 1821—1882)
Albumen silver print
8 5/8 × 7 3/4 in.

84.XM.482.1

Untitled
1935—36
MAN RAY (Emmanuel Radnitsky)
(American, 1890—1976)
Gelatin silver print
7 5/8 × 9 3/4 in.

84.XM.1000.131
© Man Ray Trust ARS—ADAGP

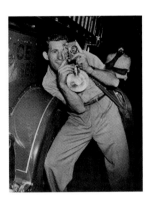

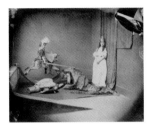

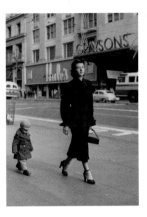

Cheese!

The photographer
nicknamed Weegee was
famous for taking
pictures of crimes and
disasters. He loved the
excitement of capturing
an emergency on film—
even in the middle of
the night!

Photographer at a Fire
1940–45
WEEGEE (Arthur Fellig)
(American, b. Austria, 1899–1968)
Gelatin silver print, ferrotyped
13 7/₁₆ × 10 11/₁₆ in.
2000.44
© Getty Images/Weegee

Dress-up

The photographer who
took this picture is the
same Lewis Carroll who
wrote *Alice in Wonder-
land.* The four children
are acting out another
classic adventure story,
this one about a hero
who saves a beautiful
princess from a dragon.

Saint George and the Dragon
1875
LEWIS CARROLL (Charles Dodgson)
(British, 1832–1898)
Albumen silver print
4 13/₁₆ × 6 3/₈ in.
84.XP.458.15

Explore

In 1991, Nicholas Nixon
used a single piece
of film to take this
photograph. That's not
unusual, but the
negative was larger
than this book: 8 x 10
inches, to be exact.

Sam, Cambridge
1991
NICHOLAS NIXON
(American, b. 1947)
Gelatin silver print
7 11/₁₆ × 9 11/₁₆ in.
2000.28.12
© Nicholas Nixon

Follow-the-
leader

At first glance, this
photograph shows a
little boy following
his mother. But look
again. The boy is busy
avoiding the cracks in
the sidewalk, while his
mother is watching the
photographer.

Market Street, San Francisco
1945
DOROTHEA LANGE
(American, 1895–1965)
Gelatin silver print
8 5/₁₆ × 6 1/₁₆ in.
2000.50.20
© Oakland Museum of California, the City of
Oakland

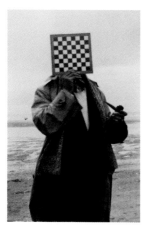

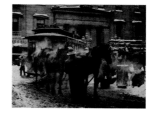

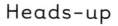

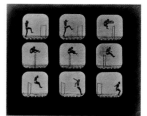

Guess who?

Heads-up

Ice-cold

Jump

René Magritte (*ruh-NAY ma-GREET*) and his artist friends loved to invent their own games. He created this portrait of a chess player to make people laugh. Peekaboo!

Have you figured out what the people in this photograph are looking at? Find a clue pinned on a woman's jacket.

On a snowy day in 1893, a New York City trolley driver stopped to take care of his horses. You can almost feel the cold one hundred years later. Brrrr!

Eadweard Muybridge (*ED-ward MY-bridge*) placed twenty-four cameras in a row to capture all the movements of this man jumping hurdles— what a great athlete!

The Giant (Paul Nougé)
1937
RENÉ MAGRITTE
(Belgian, 1898–1967)
Gelatin silver print
3³/₁₆ × 2¹/₁₆ in.
87.XM.87
© Charly Herscovici, Brussels/Artists Rights Society (ARS), New York

Baseball Fever
1957
HENRI CARTIER-BRESSON
(French, 1908–2004)
Gelatin silver print
9¹⁵/₁₆ × 6⁵/₈ in.
2004.74.9
© Henri Cartier-Bresson/Magnum Photos

The Terminal
Negative, 1893; print, 1915
ALFRED STIEGLITZ
(American, 1864–1946)
Photogravure
10 × 13¹/₈ in.
84.XM.695.23

High Jump
1878–79
EADWEARD J. MUYBRIDGE
(American, b. England, 1830–1904)
Iron salt process
7⁷/₁₆ × 8¹⁵/₁₆ in.
85.XO.362.109

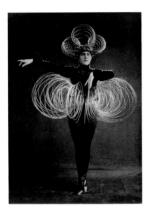

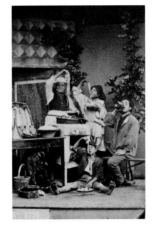

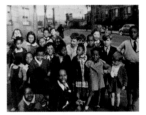

Kooky

This dancer is all
dressed up for an
outrageous per-
formance in the 1920s.
Does her wire costume
remind you of a
ballerina's tutu?

Lucky

Brassaï (*brah-SIGH*)
wanted his photographs
to show emotions. What
does a feeling look like?
Happiness is written all
over this little boy's face.

Manners

If you had traveled to
Italy in the 1870s, you
might have bought a
postcard of this
photograph as a
souvenir. Pasta anyone?

Neighborhood

Joe Schwartz loved to
photograph the
neighborhood he grew
up in. Taking pictures
was his way of keeping
a diary.

*Wire Costume from Oskar
Schlemmer's "Triadic Ballet"*
1926
K. GRILL STUDIO
(German, active Donaueschingen,
1920s)
Gelatin silver print
8 ⅞ × 6 ⅜ in.

84.XM.127.8

*Balloon Seller, Montsouris Park,
Paris*
Negative, 1931; print, 1934
BRASSAÏ (Gyula Halász)
(French, b. Hungary, 1899–1984)
Gelatin silver print
19 ⁵⁄₁₆ × 15 ¾ in.

86.XM.3.9
© ESTATE BRASSAÏ-RMN

The Spaghetti Eaters
ca. 1873
GIORGIO SOMMER
(Italian, b. Germany, 1834–1914)
Albumen silver print
3 ⁹⁄₁₆ × 2 ⁵⁄₁₆ in.

84.XD.1157.715

*Posin', Kingsboro Housing Project,
Ocean Hill, Brooklyn*
1947
JOE SCHWARTZ
(American, b. 1913)
Gelatin silver print
10 ½ × 13 ½ in.

2004.53.9
© Joe Schwartz

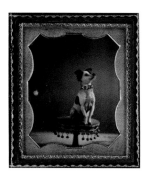

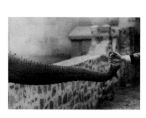

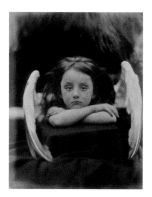

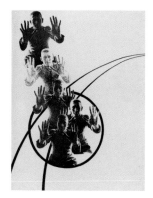

Obedient

Imagine the year 1854.
Imagine having to sit
perfectly still for five
minutes just to have
your picture taken.
Now imagine your dog
doing that!

Peanut

Garry Winogrand's
photograph is really
about what you CAN'T
see. If elephants could
talk, this one might say,
"More, please!"

Quiet Time

After hours of posing for
her Great Aunt Julia,
who was a famous
photographer, Rachel
Gurney was too tired to
look like an angel. The
swan's wings were very
heavy.

Repeat

László Moholy-Nagy
(*LAHZ-lo mo-HOLEE
nahdj*) experimented
with photography. By
combining it with
drawing, cutting, and
pasting, he turned two
hands into ten.

Skinny

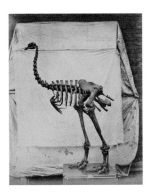

In 1854, the British Museum in London hired Roger Fenton to take pictures of this ostrich skeleton. Before photography was invented, an artist would have had to draw every single bone.

Tilt

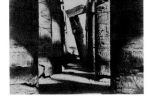

In Egypt, Gustave Le Gray waited for just the right time of day to photograph these forty-five-foot-high columns. Did you notice the hieroglyphics?

Upside down

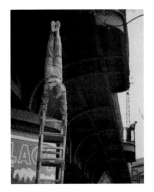

Photographer André Kertész (*AN-dray ker-TESH*) caught this circus performer at exactly the right moment. Thanks to this photograph, his handstand will go on forever!

Vroom!

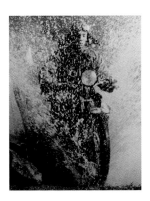

No action was too daring for Martin Munkacsi (*mun-KA-chee*) to capture with his camera. He once strapped himself to a race car to get the perfect picture!

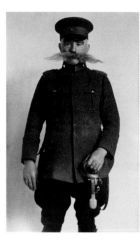

Whiskers

In 1926, August Sander (*ow-GOOST TSAN-der*) photographed this policeman posing with his weapon. You don't see police officers—or mustaches—like this one anymore!

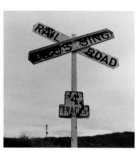

X marks the spot

Walker Evans liked this railroad sign because it told a story about train travel in America. Did you know that photography and railroads were both new inventions in the 1830s?

Y!kes

It took photographer Philippe Halsman (*fill-EEP HALS-man*) and artist Salvador Dalí (*SAHL-va-dor dah-LEE*) five hours and twenty-six tries to create this topsy-turvy scene.

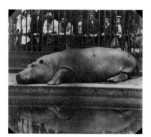

Zzzzzzz

This snoozing hippo was captured on the Nile River and sent as a gift to Queen Victoria. Who's inside the cage in this photograph? The people at the zoo!

Getty Publications
1200 Getty Center Drive
Suite 500
Los Angeles, California 90049-1682
www.getty.edu

Mark Greenberg, *Editor in Chief*

Project Staff

John Harris, *Editor*
Catherine Lorenz, *Designer*
Amita Molloy, *Production Coordinator*
Virginia Heckert, *Curatorial Liaison*

Photography provided by Imaging Services at the
J. Paul Getty Museum.

Library of Congress Cataloging-in-Publication Data

Gelber, Lisa.
 P is for peanut : a photographic ABC / Lisa Gelber, Jody
Roberts.
 p. cm.
 ISBN 978-0-89236-878-5 (hardcover)
 1. Photography--Juvenile literature. 2. Alphabet books. I.
Roberts, Jody. II. J. Paul Getty Museum. III. Title.
 TR149.G45 2007
 770--dc22
 2006033018

Printed and bound by Tien Wah Press, Singapore

Front cover: Detail of Garry Winogrand, *Untitled, New York
City*, 1961—63. (See "P is for Peanut.")

Back cover: Detail of André Kertész, *Circus Performer*,
ca. 1920. (See "U is for Upside down.")

Acknowledgments

This book simply would not have been possible without
the inspired editing of John Harris and the wonderfully
imaginative design of Catherine Lorenz. Amita Molloy
not only managed production on this book but, in fact,
first brought it to Mark Greenberg's attention, and
Virginia Heckart in the Department of Photographs gave
us invaluable guidance through their vast collections.
Our thanks to them all.

—Lisa Gelber and Jody Roberts